PHOTOGRAPHIC FILTERS
A Programmed Instruction Handbook

D0002737

PHOTOGRAPHIC FILTERS

by L. Stroebel

A Programmed
Instruction Handbook

Morgan & Morgan, Inc., Publishers
Dobbs Ferry, New York

Morgan & Morgan, Inc.
Publishers
145 Palisade Street
Dobbs Ferry, N.Y. 10522

International Standard Book
Number 0-87100-036-9

Library of Congress Catalog
Card Number 72-83109

Printed by Morgan Press

Printed in U.S.A.

FOREWORD

A filter is a kind of strainer or sieve. Photographic filters work by holding back some of the light that forms the image on film or other photosensitive material. There are several kinds of photographic (or optical) filters, and this book will give you an understanding of the way in which they work and how they are used. A suitable filter can be used in front of a camera lens, for example, to darken an overbright sky in a beach or snow scene; to get better reproduction of subject colors on black-and-white or color films; to reduce reflections and glare from water, snow, or glass; to permit adjustment of aperture and shutter settings to reduce depth of field and to obtain controlled blur effects; and for quite a number of other purposes.

As you go through the frames of this book in succession, you will learn much about optics and color. This knowledge will increase your skill in using your camera. After all, taking better pictures is the whole object of the game.

In this day of "automatic" cameras, almost anyone can press a button and "snap" a recognizable picture. Only the

skilled and knowledgeable photographer can rise above the simple mechanics of the "snapshot" and produce truly excellent pictures deserving of recognition and acclaim.

Alfred G. Wilson

CONTENTS

INTRODUCTION

PHOTOGRAPHIC FILTERS is a programmed book. Therefore, the format is probably unlike most books you have encountered. Essentially, programmed instruction is a process whereby learning materials are arranged in a sequence of small steps. At each step, you will be required to interact with the material by completing a statement, selecting an alternative response or performing some other task. Once you have made your response, the program provides you with the correct response for comparison. In this way, you become more involved in the learning process than is possible with a conventional book. You will find that PHOTOGRAPHIC FILTERS will guide you through a series of such steps to the achievement of the objectives.

We are now near the end of the second decade of the Programmed Instruction Era. It was in the mid-fifties that B. F. Skinner developed the principles and techniques of programmed instruction. PHOTOGRAPHIC FILTERS is written according to these principles

and techniques.

In the early history of programmed instruction, many enterprising individuals "invented" teaching machines. Unfortunately, this produced a period in which hardware or gadgetry dominated the field of programmed instruction. It soon became apparent to most professional programmers that the program, the software, was the name of the game. This resulted in a greater emphasis on the preparation of the instructional material and the relegation of hardware considerations to a lower priority.

Even though professional programmers came to focus on the instructional material and not the hardware, the emphasis was still on a program. This caused many programmers to focus their attention on developing the end product, the program, with little or no regard for the means; that is, "Who are the target learners?" "What do I want the learner to be able to do after he has worked through my program?" "Does my program 'work'?"

During the last three or four years, the enduring impact of programmed instruction on the field of instructional

design has become more and more apparent. That is, the greatest transfer value of programmed instruction to improving any instructional technique or procedure lies in the programming process — the way in which the material was developed. Whether the end product is a lecture, a program, a film, a seminar or whatever, is not the most crucial point. The process through which this instructional material was developed and tested is far more important. Programmed instruction has at least taught us that the production of quality instruction demands an explicit assessment of the target learner's entering behavior and validation of this preassessment through diagnostic testing; it demands the establishment of objectives stated in terms of learner behavioral outcomes that are observable and measurable; it demands the prior development of reasonably objective evaluation procedures for measuring the extent to which the objectives have been achieved; and finally, it demands that instructional material be validated through a series of trials with the learners for whom it was written, followed by revisions, and repeated

15

until learners are able to meet the objectives.

The future of programmed instruction will not only be limited to writing programs like PHOTOGRAPHIC FILTERS, but will extend to a whole host of instructional procedures which utilize a variety of learner groupings, instructional methods and media. Process is programmed instruction's most important product.

Dr. Stroebel's highly practical unit on PHOTOGRAPHIC FILTERS was developed following the process approach described above. He is one of the more than seven hundred graduates of the programmer training courses conducted at the University of Rochester since 1961. As you will see, the resultant product of Dr. Stroebel's work does credit to both the programming process approach to instructional design and to his training as a programmer, teacher and photographer.

Robert G. Pierleoni, Ed.D.

The University of Rochester
Rochester, New York

INTRODUCTION (Part II)

Photographs serve a wide range of functions in our contemporary civilization—from expressive to scientific, from amateur to professional. Filters also serve a variety of functions in the production of those photographs. Some filters are essential to obtaining realistic images while others are used to purposely destroy realism. Some filters enable us to achieve a selective focus effect to emphasize one part of a scene and others enable us to record that which the eye cannot see. This book was written for those who want to learn the fundamentals concerning filters and their applications— amateur photographers, students of photography, professional photographers, and "nonphotographers" who use the photograph as a tool in their own fields of specialization.

This publication evolved from many years of helping students learn about filters, using a variety of techniques including lectures, demonstrations, projects, textbook assignments, and the "discovery" method. Although no single method of instruction can be considered the ultimate solution to the

learning problem, the results obtained with this programmed material have been gratifying with respect to scores obtained on tests, the application of the contents to picture making, and the enthusiasm of students for this method of learning. Many useful suggestions made by some of the several hundred students who have now worked with this material have been incorporated in the final manuscript. I also want to thank those students who encouraged me to make this instructional program available to persons who do not have the opportunity to study photography in an educational institution.

Having borrowed many books from personal and other types of libraries, it has become obvious to me that there are two kinds of readers — those who like to underline and make notes in books, and those who treat the printed page as something sacred. This book was designed for the note makers. After each concept is presented in the programmed part of this book, you will be expected to make a response to demonstrate to yourself that you understand the concept. Maximum learning requires that you write, not

just think, your responses. If you prefer not to write in the book (and please don't if you are using a borrowed copy), you will learn as much by writing your responses on a separate piece of paper. Although the correct response for each frame of the program is printed in the border on the right of the following frame, it is important that you write your response before checking the printed one. The purpose of the printed response is to let you know immediately whether you understand the corresponding concept well enough to continue, or whether you should stop and review the preceding material.

Three filters and a gray scale are supplied with the book, in an envelope attached to the back cover. These items are needed for frames 41, 42, 71-73 and 78, and question 14 on the test. In the event that these items are misplaced, the reader may substitute any red contrast filter, any two polarizing filters, and any reflection gray scale on which the density of each step is marked. Replacements may also be obtained from the publisher for a small charge.

Following the program are a list of objectives (under the heading "What You Have Learned"), a multiple-choice test, a glossary, and a list of references. It would be appropriate for you to read the objectives next, but if you are anxious to begin participating actively, look over the list of basic terms on the following pages and then move on to reading the program and writing your responses.

L. Stroebel

PRE-TEST OF SOME BASIC TERMS

Since this book assumes you have some familiarity with the following 25 terms, it is desirable to clear up any possible misunderstandings before continuing with the main part of the book. Following each of the 25 terms is a list of five choices. Select the choice that is most similar in meaning to, mostly closely associated with, or an example of the term. Indicate your answer by circling the corresponding letter—A, B, C, D, or E—on the left. After you have finished all 25 terms, make certain your answers are correct by following the instructions below the last term. The glossary beginning on page 109 can be used to clarify the meanings of any terms you have difficulty with.

1. ABSORB

 A. To reflect
 B. To color
 C. To swallow up
 D. To repeat
 E. To multiply

2. APERTURE

 A. Diaphragm opening
 B. 1/100 second
 C. Bellows
 D. Shutter opening
 E. Angle of view

3. BRIGHTNESS

 A. Sensitivity
 B. Lightness
 C. Focus
 D. Bluish
 E. Graininess

4. CONTRAST

 A. Density difference
 B. Dark
 C. Thin
 D. Reticulation
 E. Sabattier effect

1.

A.
B.
C
D.
E.

2.

A
B.
C.
D.
E.

3.

A.
B
C.
D.
E.

5. DENSITY

 A. 100 lines/mm
 B. Exposure meter
 C. Sensitometer
 D. Densitometer
 E. Stop bath

6. DEPTH OF FIELD

 A. Covering power
 B. Perspective
 C. Focal length
 D. Developing time
 E. Image sharpness

7. FULL STOP

 A. 1/100, 1/50, 1/25
 B. 0.3, 0.6, 0.9
 C. 100, 200, 400
 D. 8, 11, 16
 E. 3, 4, 5

8. FILM SPEED

 A. Latent image
 B. ASA 200
 C. 7 minutes at 68°
 D. Expiration date
 E. 8X

4.

A
B.
C.
D.
E.

5.

A.
B.
C.
D
E.

6.

A.
B.
C.
D.
E

7.

A.
B.
C.
D
E.

9. GLARE REFLECTION

 A. Bright
 B. Diffuse
 C. Dark
 D. Double
 E. Colored

10. GRAY SCALE

 A. Exposure meter
 B. Black, white
 C. Red, green, blue
 D. Resolving power
 E. Time and temperature

11. INFRARED

 A. Supersonic
 B. 400nm
 C. Invisible
 D. Halftone
 E. Gamma

12. NEGATIVE

 A. Reversed tones
 B. Contact
 C. D-72
 D. Blue, yellow
 E. 35mm

8.

A.
B
C.
D.
E.

9.

A
B.
C.
D.
E.

10.

A.
B
C.
D.
E.

11.

A.
B.
C
D.
E.

13. PANCHROMATIC

 A. ASA 200
 B. Fine grain
 C. Color sensitivity
 D. Resolving power
 E. Acutance

14. PHOTOGRAPHIC
 EXPOSURE

 A. Illuminance x time
 B. 1/100 second
 C. $f/16$
 D. Reciprocity law failure
 E. Bellows extension

15. POSITIVE

 A. False
 B. Realistic
 C. Color
 D. Photomechanical
 E. Black-and-white

16. PRINT

 A. Camera
 B. Developing tank
 C. Enlarger
 D. Densitometer
 E. Sensitometer

12.

A
B.
C.
D.
E.

13.

A.
B.
C
D.
E.

14.

A
B.
C.
D.
E.

15.

A.
B
C.
D.
E.

17 PRISM 16.

 A. Opaque A.
 B. Flat B.
 C. Anamorphic C
 D. Complementary D.
 E. Spectrum E.

18. PROPORTION 17.

 A. 1/2 A.
 B. 100 B.
 C. Large C.
 D. 70mm D.
 E. $75°$ E

19. REVERSAL FILM 18.

 A. Ektacolor A
 B. Ektachrome B.
 C. Royal Pan C.
 D. Polycontrast D.
 E. Photo Flo E.

20. SHUTTER SPEED 19.

 A. Focal plane A.
 B. Between-the-lens B
 C. 1/250 C.
 D. Relative aperture D.
 E. ASA 400 E.

21. TRANSMIT

 A. To heat
 B. To obstruct
 C. To distort
 D. To pass
 E. To decrease

22. TRANSPARENCY

 A. Slide
 B. Print
 C. Mural
 D. Telephoto
 E. Reduction

23. TUNGSTEN

 A. Electronic flash
 B. Photoflood
 C. Fluorescent
 D. Daylight
 E. Phosphorescent

24. ULTRAVIOLET

 A. Electromagnetic radiation
 B. Toner
 C. Sensitizing dye
 D. Antihalation backing
 E. Color

20.

 A.
 B.
 C
 D.
 E.

21.

 A.
 B.
 C.
 D
 E.

22.

 A
 B.
 C.
 D.
 E.

23.

 A.
 B
 C.
 D.
 E.

25. WHITE LIGHT

A. Laser
B. Stroboscopic
C. Invisible
D. Daylight
E. 700nm

The correct answers are identified
by the letters in the right-hand column
that are *not* followed by periods.

24.

A
B.
C.
D.
E.

25.

A.
B.
C.
D
E.

PROGRAMMED INSTRUCTION

DIRECTIONS:

This is an instructional program on
the subject of Photographic Filters.
Your participation will consist of:

(1) reading the written material,

(2) writing responses in the spaces,

(3) checking your responses with
the correct responses on the
right edge of the next frame.

If your response is correct, proceed to
the next frame.

If your response is incorrect, draw a
line through the incorrect response.
Reread the frame (and preceding
frames if necessary). If you now
understand the correct response, write
it in the left margin. If you still do not
understand it, place a "?" in the left
margin.

Cover the responses on the right edge
of each page with a piece of paper.
Move the paper down to reveal the
correct answer only after you have
written your response to that frame.

A motion picture and film strip
series based on the contents of this
book are available for purchase from
Morgan & Morgan. Write for
further information.

1. A triangle can be useful in learning the names and important relationships of colors. The names RED, GREEN, and BLUE are placed at the points of the triangle. In the drawing, the name _____ would be placed at the top point.

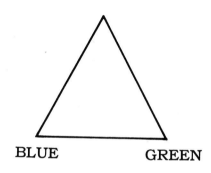

BLUE GREEN

2. RED, GREEN, and BLUE are referred to as PRIMARY colors because red, green, and blue light can be added together to obtain white light. Conversely, we can think of white light as being composed of three _____ colors.

1.
Red

3. Color patches have been substituted for the names on the triangle. Beginning at the top and reading clockwise, the names of the colors are_____ , _____ , and_____ .

2.
Primary

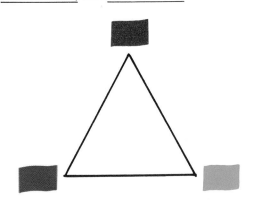

4. Another method of labeling the triangle is to use the first letter of the name of each color. With this system, the points of the triangle would be labeled _____ , _____ , and _____ .

3.
Red
Green
Blue

5. If you were introduced to color in primary school with an art medium such as crayons or water colors, you probably heard colors other than red, green, and blue referred to as primary colors. In the study of filters, however, we are concerned with the colors of

4.
R
G
B

light. To avoid confusion, red, green, and blue light are identified as ADDITIVE primary colors. This term is appropriate when you recall that white light can be formed by _____ the three primary colors of light together.

6. When two primary colors of light are added together, a new color is formed. RED and BLUE light combined form the color MAGENTA. This relationship would be indicated on the diagram by placing the word _____ on the side of the triangle between the component colors red and blue.

5.
Adding

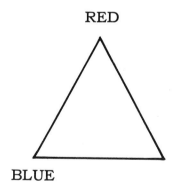

RED

BLUE

7. Color patches have been placed on the triangle to illustrate that adding red and blue light forms a new color named_____ .

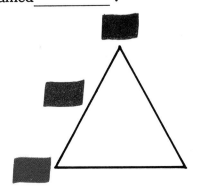

8. The color formed by adding two primary colors of light is referred to as a SECONDARY color. Identify the following colors as PRIMARY or SECONDARY:

 RED_____

 MAGENTA_____

 BLUE_____

9. Adding primary colors BLUE and GREEN forms a new_____ color CYAN.

6.
Magenta

7.
Magenta

8.
Primary
Secondary
Primary

10. A CYAN color patch has been placed on the triangle between the component primary colors _____ and _____.

9.
Secondary

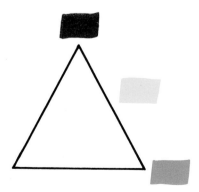

11. Although you may not have been familiar previously with the secondary colors MAGENTA and CYAN, everyone recognizes the color formed by adding RED and GREEN light. The name of this SECONDARY color on the diagram is _____.

10.
Blue
Green
(Either order)

12. To summarize, the names of the SECONDARY colors (reading clockwise on the triangle) are YELLOW, _____, and _____.

11.
Yellow

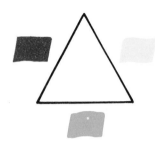

13. Just as PRIMARY colors of light can be added together to form SECONDARY colors, SECONDARY colors can be separated into their component PRIMARY colors by passing the light through a prism, as illustrated. Thus, CYAN light entering a prism is separated into BLUE light and GREEN light. YELLOW light entering a prism would be separated into _____ light and _____ light.

12.
Cyan
Magenta

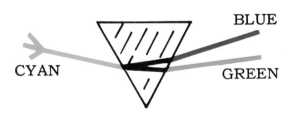

40

14. In a similar manner, MAGENTA light entering a prism would be separated into _____ light and _____ light.

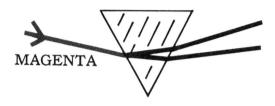

MAGENTA

15. Since the three primary colors of light can be added together to form white light, it is logical that one primary color and the secondary color containing the other two primary colors can also form white light. Such combinations are called COMPLE-MENTARY colors and are located opposite each other on the triangle. Thus, BLUE light and _____ light are complementary colors.

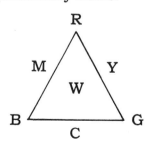

16. The other two combinations of complementary colors of light are GREEN and MAGENTA, and RED and _____.

17. For review purposes, write the names of the three primary colors in alphabetical order in the spaces on the left below and the names of the corresponding complementary colors in the spaces on the right:

_____ _____

_____ _____

_____ _____

18. When white light (a mixture of red, green, and blue light) enters a RED filter, RED light is TRANSMITTED, and the BLUE and GREEN components are ABSORBED. Thus, less light leaves the filter than enters because the filter _____ some of the light.

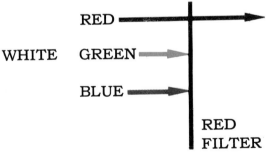

WHITE

RED

GREEN

BLUE

RED FILTER

15.
Yellow

16.
Cyan

17.
Blue—yellow
Green—magen
Red—cyan

19. Since a GREEN filter transmits GREEN light and a BLUE filter transmits BLUE light, we can generalize that when white light enters a filter, the filter will _____ light of the same color and _____ light of other colors.

20. Secondary color filters also transmit their own color of light. That is, a CYAN filter transmits CYAN, a MAGENTA filter transmits _____, and a _____ filter transmits _____.

21. So far we have been considering what happens when white light enters filters. The same RULE applies when colored light enters. The rule states that a filter transmits light of the same color and absorbs light of other colors. Thus, if separate beams of red, green, and blue light enter a RED filter, the _____ beam will be transmitted and the _____ and _____ beams will be absorbed.

18.
Absorbs

19.
Transmit
Absorb

20.
Magenta
Yellow
Yellow

22. In a similar manner, when magenta light enters a red filter, the red component is transmitted and the blue is absorbed. If yellow light enters a red filter, the _____ component will be transmitted and the _____ component will be absorbed.

21.
Red
Green
Blue

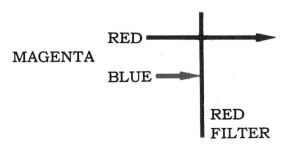

MAGENTA

RED ⟶

BLUE ⟶

RED
FILTER

23. Since cyan light contains no red component, all of the cyan light that enters a red filter will be absorbed. The color of the filter that will absorb both component colors in yellow light is _____.

22.
Red
Green

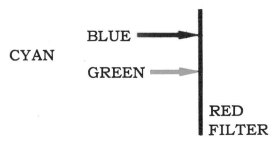

CYAN

BLUE ⟶

GREEN ⟶

RED
FILTER

24. You have learned how PRIMARY color filters affect both primary and secondary colors of light. Now we will consider SECONDARY color filters. A MAGENTA filter transmits light of the same color (magenta) and the component colors (red and blue) freely. Whereas a red filter transmits only the red part of magenta light, a magenta filter transmits _____ of the entering red light.

23.
Blue

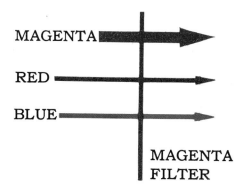

MAGENTA

RED

BLUE

MAGENTA FILTER

25. In a similar manner, a yellow filter transmits yellow, red, and green light, and a cyan filter transmits _____, _____, and _____ light.

24.
All

26. Since all secondary colors contain two of the three primary colors, secondary color filters cannot absorb all of the entering light of any secondary color. A yellow filter, for example, in addition to transmitting all entering yellow light transmits the green component of cyan light and the red component of magenta light.

A CYAN filter, in addition to transmitting cyan light, transmits the _____ component of yellow light and the _____ component of magenta light.

25.
Cyan
Blue
Green
(In any order)

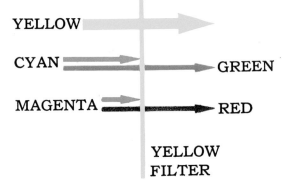

You should now be able to identify the colors of light transmitted and absorbed for each of the combinations of light and filter in frames 27 to 34. Write the names of the colors in the spaces to the right of the filters, using the primary colors RED, GREEN, and BLUE only. If your answer is incorrect, you may want to review the frame indicated below the answer.

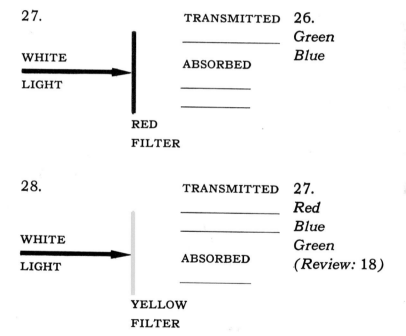

27.

WHITE
LIGHT

RED
FILTER

TRANSMITTED

ABSORBED

26.
Green
Blue

28.

WHITE
LIGHT

YELLOW
FILTER

TRANSMITTED

ABSORBED

27.
Red
Blue
Green
(Review: 18)

29.

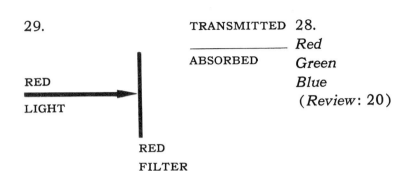

RED
LIGHT

RED
FILTER

TRANSMITTED

—————— ABSORBED

28.
Red
Green
Blue
(*Review*: 20)

30.

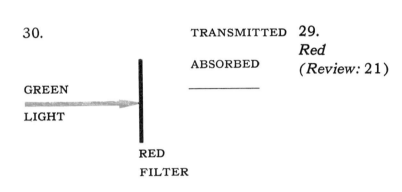

GREEN
LIGHT

RED
FILTER

TRANSMITTED

ABSORBED

——————

29.
Red
(*Review*: 21)

31.

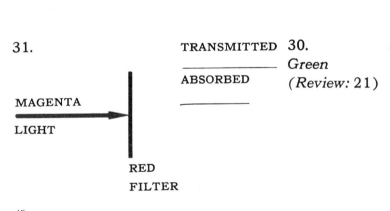

MAGENTA
LIGHT

RED
FILTER

TRANSMITTED

—————— ABSORBED

——————

30.
Green
(*Review*: 21)

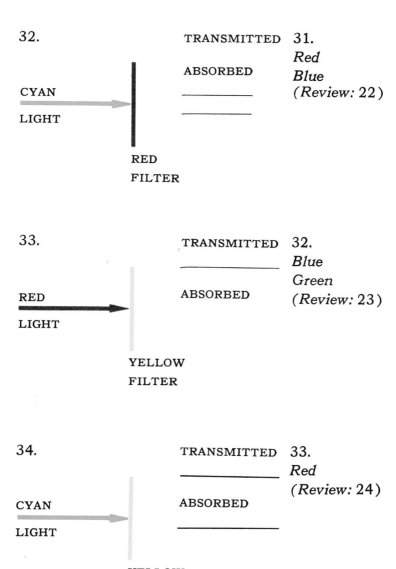

32.

CYAN LIGHT

RED FILTER

TRANSMITTED

ABSORBED

31.
Red
Blue
(Review: 22)

33.

RED LIGHT

YELLOW FILTER

TRANSMITTED

ABSORBED

32.
Blue
Green
(Review: 23)

34.

CYAN LIGHT

YELLOW FILTER

TRANSMITTED

ABSORBED

33.
Red
(Review: 24)

35. In this program we will consider the following types of photographic filters: CONTRAST, NEUTRAL DENSITY, COLOR COMPENSATING, POLARIZING, and SPECIAL PURPOSE. So far, we have been concerned only with CONTRAST filters. Contrast filters either freely transmit or completely absorb primary colors of light.

A cyan filter that transmits all of the entering blue light and green light and absorbs all of the entering red light would be classified as a _____ filter.

34.
Green
Blue
(Review: 26*)*

36. An important use for CONTRAST filters is to record colored objects lighter or darker on black-and-white photographs than they would be recorded without a filter. If blue sky appears too light on a photograph, for example, another photograph can be made using a contrast filter over the camera lens to make the sky _____.

35.
Contrast

37. The triangle can be used to predict which colors will be lightened and which will be darkened with any contrast filter. The RULE (in terms of the print) is—a filter will lighten its own

36.
Darker

color and its adjacent colors and will darken the opposite color and its adjacent colors. Therefore, a RED filter will lighten RED, YELLOW, and MAGENTA, and will darken

_____ , _____ , and_____ .

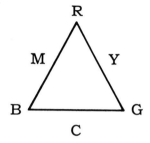

38. The triangle can also be used to select an appropriate filter for a given purpose. For example, if you want to darken the image of a yellow object on a black-and-white photograph, you can use a BLUE, a_____, or a _____ filter.

37.
Cyan
Blue
Green
(In any order)

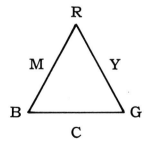

51

39. If you want to lighten the image of a red object, you can use a _____, a _____, or a _____ filter.

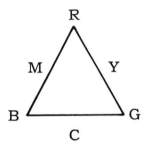

40. A second method for predicting whether a contrast filter will lighten or darken a subject color is to look at the subject through the filter. If the color appears darker when viewed through the filter than without, the filter will darken the color on the photograph. It follows that if a subject color appears lighter when viewed through a filter, the filter will _____ the color on the photograph.

38.
Magenta
Cyan
(Either order)

39.
Red
Magenta
Yellow
(In any order)

41. The color patch and the gray reference patch on the left appear approximately the same in brightness and they would be recorded as approximately the same tone of gray on a black-and-white photograph. View the color patch on the left through the red filter provided and observe that the color now appears lighter than the gray patch.

View the color patch on the right without a filter and then through the red filter. You can predict that the filter will_____ this color on a photograph.

40.
Lighten

42. It is easier to observe the effect a filter has on a subject color when the color is compared with a gray area of equal lightness. Slide the gray scale provided back and forth near the color patch on the left and observe that the step marked "1.30" is the closest lightness match.

Compare the gray scale with the color patch on the right. The closest

41.
Darken

lightness match is obtained with
the step marked _____.

Viewed through the red filter, the
closest lightness match is obtained
with the step marked_____.

43. A third method for predicting the
effect a contrast filter will have on a
subject color involves reasoning based
on your existing knowledge of the
absorption and transmission character-
istics of filters. Since a red filter trans-
mits the light from a red object more
freely than the white light from a gray
reference object, red objects photo-
graphed through a red filter will be
recorded DARKER on the
NEGATIVE and therefore _____
on the PRINT.

42.
.70
1.30
(With daylight
illumination.
Slightly
larger with
tungsten
illumination.)

44. Conversely, since the light from
blue objects is absorbed by a red
filter, blue objects will be recorded
_____ on the NEGATIVE, and
_____ on the PRINT.

43.
Lighter

45. Expressed in general terms, if a filter transmits a larger PROPORTION of the light from a colored object than from a gray reference object, the filter will darken the colored object on the negative and _____ it on the print.

44.
Lighter
Darker

46. For example, a red filter transmits ALL of the light from a red object. If we think of the white light from the gray reference object as consisting of equal parts of red, green, and blue, the red filter will transmit ONE-_____ of the white light.

45.
Lighten

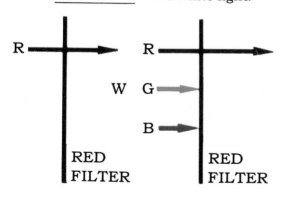

47. Because the red filter transmits a_____ proportion of the light from the red object than from the gray, it will record the red object _____ on the PRINT.

46.
Third

48. When photographing a green object through a red filter, the filter transmits a_____ proportion of the light from the green object than from a gray, and will therefore record the green object_____ on the print.

47.
Larger
Lighter

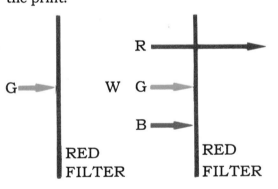

G⟶ W R ⟶
 G ⟶
 B ⟶

RED FILTER RED FILTER

49. Apply the same reasoning to determine if one of the PRIMARY color filters (R-G-B) will lighten or darken a SECONDARY color object (C-M-Y). A red filter will transmit ONE-_____ of the light from a magenta object and ONE-_____ of the white light from a gray object.

48.
Smaller
Darker

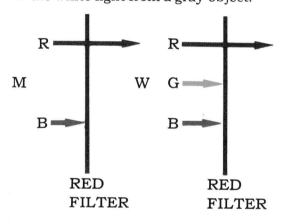

RED
FILTER

RED
FILTER

50. Therefore, since the red filter transmits a _____ proportion of the light from the magenta object, it will be recorded _____ on the print.

49.
Half
Third

51. Apply the same reasoning for the final combination, a SECONDARY color filter and a SECONDARY color object. Since a yellow filter transmits a _____ proportion of the light from a magenta object than from a gray, the filter will record it _____ on the print.

50.
Larger
Lighter

R ➞ | ➞ R ➞ | ➞

M W G ➞ | ➞

B ➞ | B ➞ |

YELLOW YELLOW
FILTER FILTER

52. Whereas CONTRAST filters absorb some colors entirely and transmit others freely, NEUTRAL DENSITY (ND) filters absorb all colors equally. Thus, a ND filter that absorbs ½ of entering red light will absorb _____ of entering green, blue, and white light.

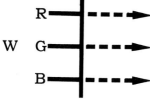

ND
FILTER

53. Since a ND filter absorbs all colors equally, the neutral density filter itself should appear_____ in color.

54. ND filters are calibrated in units of DENSITY. Although DENSITY can be converted to TRANSMITTANCE mathematically (by taking the reciprocal of the antilog of the density), we will be concerned only with easily remembered combinations in this program. Three combinations of density and transmittance are listed below:

DENSITY	TRANSMITTANCE
0.0	1
0.3	½
0.6	¼

By extending the two series of numbers, it can be predicted that a density of 0.9 will correspond with a transmittance of_____.

55. In other words, each time the density is increased by 0.3, the transmittance is divided by_____.

53.
Gray or Neutral

54.
⅛

56. Another easily remembered series
of combinations is based on the whole
numbers of density:

DENSITY	TRANSMITTANCE
0.0	1
1.0	1/10
2.0	1/100

A density of 3.0 corresponds with a
transmittance of _____.

55.
2

57. This relationship can also be
stated as a rule: as the density is
increased by 1.0, the transmittance is
divided by_____.

56.
1/1000

58. ND filters are useful when a
photographer wants to alter the
f-number to decrease depth of field
(for emphasis of a certain part of the
scene) or to alter the shutter speed to
obtain a blurred image of a moving
object (for an impression of move-
ment). Addition of appropriate ND
filters will compensate for increases in
the amount of light received by the
film as these changes in f-number
and shutter speed are made. For
example, adding a ND 1.0 filter
(transmittance $= 1/10$) allows the
shutter speed to be changed from

57.
10

1/100 second to 1/10 second without altering the exposure.

Adding a ND 2.0 filter (transmittance = 1/100) allows the shutter speed to be changed from 1/100 second to _____ second.

59. Similarly, if a photographer wants to open up one stop to decrease depth of field, he would add a ND 0.3 filter (transmittance = ½). To open up two stops, he would add a ND 0.6 filter (transmittance = ¼), and to open up three stops, he would add a ND _____ filter.

60. Another use for ND filters is to permit the photographer to use two films rated at different speeds on the same subject without changing the f-number or the shutter speed. For example, if a 200 speed black-and-white film and a 100 speed color film are used, a ND 0.3 filter (transmittance = ½) would be added for the faster black-and-white film.

If a 400 speed Polaroid film and a 100 speed color film are used, a ND _____ filter would be added for the Polaroid film.

58.
1

59.
0.9

61. COLOR COMPENSATING filters are most commonly used over the camera lens when exposing color film and over the enlarger lens when exposing color prints for the purpose of producing controlled changes in the color balance of the images. Color Compensating filters are supplied in the same three additive primary colors and three additive secondary colors as contrast filters: red, green, _____ , cyan, magenta, _____ .

60.

0.6

62. Each of the six colors of COLOR COMPENSATING filters is supplied in a variety of densities from .025 to .50. These filters are designated by the letters "CC" (for Color Compensating), followed by the density (with the decimal omitted) and the first letter of the name of the color. Thus CC05Y designates a yellow Color Compensating filter having a density of .05.

The designation for a magenta Color Compensating filter having a density of .50 is _____ .

61.

Blue

Yellow

63. Whereas the density of a Neutral Density filter remains constant for all colors of entering light, the density of a color filter will vary for different colors of entering light. To avoid this complication, the density of Color Compensating filters is determined for the color of light that is COMPLE-MENTARY to the color of the filter. Thus, the density of a yellow CC filter is determined for blue light, and the density of a magenta CC filter is determined for_____light.

62.
CC50M

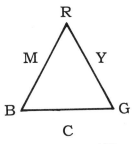

64. Two or more Neutral Density filters can be used together over a lens. The density of the combination of filters is the sum of the individual densities. Thus, two ND .30 filters have the same density as one ND .60 filter.

One ND .10 filter plus one ND .90 filter have the same density as one ND_____filter.

63.
Green

65. Two or more Color Compensating filters can also be used together. When the filters are the same color, the individual densities are added together the same as with Neutral Density filters. Thus, a CC10Y filter plus a CC20Y filter produce the same effect as one _____ filter. The procedure for adding Color Compensating filters having different colors is more complex, and is beyond the scope of this program.

66. When using reversal color camera film or printing materials, the change produced by a Color Compensating filter is similar to the visual effect when looking through the filter. Thus, if a trial color transparency or print appears too yellow, a Color Compensating filter having a COMPLEMENTARY blue color should be used to absorb some of the yellow light.

 If a trial color transparency appears too blue, a _____ Color Compensating filter should be used.

64.
1.00

65.
CC30Y

67. When making a positive color print from a color NEGATIVE (rather than positive to positive), a different procedure is necessary. If a trial color print appears too yellow, a YELLOW Color Compensating filter must be used. Similarly, if a trial color print is too GREEN, a _____ Color Compensating filter should be used.

68. POLARIZING filters absorb all colors equally the same as Neutral Density filters. The value of Polarizing filters, however, is in their ability to absorb POLARIZED light. Since one of the most common sources of polarized light is in glare reflections on non-metallic surfaces such as water, paint, plastic, wood, and glass, it can be assumed that an important use for Polarizing filters is to reduce or eliminate _____ _____.

66.
Yellow

67.
Green

69. Although a Polarizing filter over the camera lens can reduce or eliminate glare reflections, two limitations should be noted. One is that the glare reflection must be on a non-_____ surface, and that the other is that the angle at which the reflection is photographed must be approximately 35 degrees.

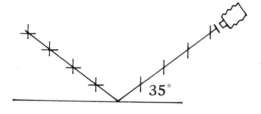

70. An additional requirement for the elimination of glare reflections is that the Polarizing filter must be rotated until the "optical slits" in the filter are at right angles to the direction of vibration of the polarized light from the reflection. Thus, there are three requirements for the effective elimination of glare reflections relating to the following: the nature of the surface, the angle at which the reflection is photographed, and the_____ of the_____ filter.

71. Use one of the polarizing filters provided to demonstrate these three requirements to yourself. First, tilt a book or magazine that is printed on glossy paper to obtain a glare reflection from a window or other light source when viewed at an angle of approximately 35 degrees, as illustrated with the camera in the drawing in frame 69. Rotate the filter in front of one eye to obtain maximum reduction of the reflection. When the filter is now rotated 360 degrees (one full turn), the reflection is eliminated or reduced_____time(s).

72. Second, lay a flat metallic object such as a piece of foil or a knife blade on the page and observe the effect of rotating the filter. When the filter is rotated 360 degrees, the reflection is eliminated or reduced_____ time(s).

70.
*Rotation
Polarizing*

71.
Two

73. Third, change your position so that the light comes over your shoulder to produce a glare reflection on the book or magazine when it is viewed at an angle of 90 degrees—that is, when viewed perpendicularly. When the filter is rotated 360 degrees, the reflection on the paper is eliminated or reduced_____time(s).

72.
Zero

74. If you looked at your own reflection in a mirror, holding a Polarizing filter in front of your eye would not eliminate your reflection because (1) the reflection is on a_____ surface, and (2) the angle at which you are viewing the reflection is not approximately_____degrees.

73.
Zero

75. In addition to eliminating glare reflections, Polarizing filters can be used to darken blue sky on photographs. The reason Polarizing filters can be used to darken blue sky is because a large proportion of the light from blue sky consists of _____ light.

76. Although either Polarizing filters or Contrast filters can be used to darken blue sky on black-and-white photographs, only Polarizing filters are suitable for use on color photographs. The advantage Polarizing filters have for this purpose is that they are _____ in color.

77. There is a special technique by which it is possible to minimize or eliminate glare reflections at angles other than 35 degrees and from metallic surfaces. This consists of placing a second, large Polarizing filter between the light source and the subject, so that the subject is illuminated with _____ light.

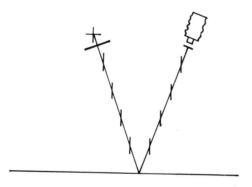

78. The principle involved in this technique can be demonstrated by sandwiching the two polarizing filters provided together and rotating one while looking at a light source, such as a ceiling light, through the combination. When the nearer filter is rotated 360 degrees, the polarized light transmitted by the farther stationary filter is almost completely absorbed _____ time(s).

76.
Neutral or Gray

77.
Polarized

79. Since it is necessary to place a Polarizing filter over each light source in addition to one over the lens, this technique can be used effectively in a photographic studio but would not be practical for photographs made

_____ .

78.
Two

80. So far, we have considered four types of filters: CONTRAST, NEUTRAL DENSITY, COLOR COMPENSATING, and POLARIZING. The final classification to be included in this program will be referred to as SPECIAL PURPOSE. Many of the filters in this category are intended for use with specific combinations of film and illumination. For example, if a color film manufactured for TUNGSTEN illumination is used with DAYLIGHT, an appropriate filter would be necessary to obtain a photograph with a normal color balance.

Another combination requiring a filter would be a film manufactured for DAYLIGHT used with _____ illumination.

79.
Outdoors

81. Special Purpose filters that enable a color film to be used with a different type of illumination than the film was manufactured for are more specifically identified as CONVERSION filters. The name implies that one type of illumination is_____into another type of illumination by the filter.

80.
Tungsten

82. Although the differences between daylight and tungsten illumination are less important for black-and-white photographs than for color photographs, the differences do cause some colors to be recorded as too light or too dark a tone of gray to appear natural. Special Purpose filters that are used to minimize these discrepancies are identified as CORRECTION filters. Since blue objects tend to be recorded too light on most black-and-white photographs made in daylight, the COR-RECTION filter is the COMPLE-MENTARY color of blue, that is,

_____.

81.
Converted

83. Both CONVERSION and COR-RECTION filters are designed to improve the realism with which colored objects are recorded on photographs. Some SPECIAL PURPOSE filters are designed to do the opposite. In crime detection photography, for example, infrared radiation may be capable of revealing detail that is not visible to the eye. To record this detail on a photograph, it is necessary to use a filter that transmits infrared radiation but_____all visible light.

84. When using filters, consideration must be given to the color sensitivity of the film or paper. Most general purpose black-and-white and color films are sensitive to all three component primary colors in white light. ORTHO-CHROMATIC film, however, is only sensitive to blue and green light. In other words, ORTHOCHROMATIC film is not sensitive to_____ light.

85. The name BLUE-SENSITIVE for a classification of black-and-white

82.
Yellow

83.
Absorbs

84.
Red

films suggests that these films are not sensitive to either_____light or _____light.

86. Although a RED Contrast filter can be used with conventional black-and-white film to lighten or darken certain colors, an attempt to use this filter with ORTHOCHROMATIC film would not be successful because the film is not_____to the light _____by the filter.

87. It would be equally unproductive (although not as disastrous) to use a BLUE Contrast filter with BLUE-SENSITIVE film. Since the film is not sensitive to the colors of light absorbed by the filter, photographs made with and without the filter would be

_____.

88. Since filters absorb some of the light that would reach the film or paper if the filter was not used, it is necessary to compensate for the loss of light either by using a larger aperture on the lens or by_____the exposure time.

89. The most common method for designating the required increase in exposure is the FILTER FACTOR. If you expose a film at settings of 1/60 second and $f/16$ without a filter and then add a filter that has a factor of 2, you can multiply the exposure by 2 either by changing the shutter setting from 1/60 to 1/30 second or by changing the aperture setting from $f/16$ to $f/$_____ .

90. Since the amount of light transmitted by a lens doubles each time the aperture is opened one stop, the aperture changes that correspond with filter factors of 2, 4, 8, and 16 are 1 stop, 2 stops,_____stops, and _____ stops.

91. Filter factors are calculated to produce the same image density with the filter as without. Since color filters lighten some subject colors and darken others, negatives made with and without a filter cannot match in density in all areas. Therefore, the filter factor is based on white light, and will produce images having the same density in _____ subject areas.

88.
Increasing

89.
11

90.
3
4

92. An alternative method of adjusting the exposure for a filter is the publication of two film speeds, one to be used without the filter and the other with. Film speeds of 120 without a filter and 80 with a filter are equivalent to a filter factor of 120/80 or 1.5.

Film speeds of 120 and 60 are equivalent to a filter factor of

_____ .

91.
Gray or Neutral

93. One of the claimed advantages of cameras equipped with through-the-lens exposure meters is that the meter automatically compensates for the loss of light when a filter is added. If the meter indicates one stop larger aperture when a filter is added, the equivalent filter factor is 2.

If the meter indicates two stops difference, the equivalent factor is

_____ .

92.
2

94. There are several possible sources of information on filters. The only information normally printed on the FILTER or its CONTAINER is an identifying name, number, or letter. FILM DATA SHEETS usually provide filter factor data for filters most

93.
4

commonly used with the film, but little or no additional information about the filters. The most complete information on specific filters is provided in **FILTER DATA BOOKS** published by the filter manufacturers. In addition to filter factors, these books provide data on the color of the filter, sensitive materials the filter can be used with, recommended uses, available forms, absorption curves, spectrograms, and the tonal rendering of selected subject colors. An elementary discussion of how filters work may also be included. Photographic and physics **TEXT-BOOKS** are usually more concerned with concepts and theories related to filters than with data on specific filters.

The source of information that is most readily available to photographers who are only concerned with determining the filter factor for a specific film-filter combination is the **FILM**＿＿＿＿＿ ＿＿＿＿＿.

The books on the References list are recommended for readers who are interested in doing additional reading on filters and the related topics presented in this program.

94.
Data Sheet

WHAT YOU HAVE LEARNED

Having completed this program on filters, you may be anxious to find out how well you understand the topics that were presented. The seventeen statements below were used as objectives in writing the program and indicate what you should have learned from reading it. A multiple-choice test follows the statements. The most important purpose of the test is to identify any topics you may need to review. If you want to give yourself a grade on the results, however, a scale is provided that is based on the scores of first-year college students enrolled in a photographic curriculum. A low grade will suggest the need to reread appropriate parts of this book. A high grade will indicate that you are ready to apply your knowledge to picture-making situations, and that you are prepared to read more advanced material on the subject of filters.

You should now be able to:

1) Identify primary and secondary additive colors from memory and by recognition.

2) Demonstrate an understanding of the interrelationship between primary and secondary colors by solving problems involving analysis and synthesis.

3) Demonstrate an understanding of the concepts of absorption and transmission of light by selecting the correct explanation for the decrease in intensity when light enters a filter.

4) Identify the nature of the light absorbed and transmitted by color filters, neutral density filters, and polarizing filters.

5) Identify five basic types of filters: contrast, neutral density, color compensating, polarizing, and special purpose.

6) Identify one or more reasons for using each of the five basic types of filters.

7) Demonstrate an ability to select the correct filter to solve a problem using a schematic diagram and a rule of thumb.

8) Demonstrate an ability to select the correct filter to solve a problem using the technique of visual inspection.

9) Demonstrate an ability to select the correct filter to solve a problem using the reasoning process.

10) Demonstrate an understanding of the quantitative absorption of light by filters by selecting the correct solution to a problem involving the concept of density.

11) Solve a problem involving a combination of two or more neutral density filters or two or more color compensating filters.

12) Demonstrate an understanding of the concept of spectral sensitivity of photographic emulsions by selecting an inappropriate combination of film and filter.

13) Demonstrate an understanding of the filter factor concept by selecting the correct answer to a question concerning the color of the light used to determine a filter factor.

14) Solve a problem involving the use of filter factors.

15) Solve a problem involving the use of a modified exposure index as a substitute for a filter factor.

16) Solve a problem involving the use of an exposure meter to determine the filter factor.

17) Identify a source of information about filters.

POST-TEST,
PHOTOGRAPHIC FILTERS

Indicate your answer by circling the letter—A, B, C, D, or E—on the left. The correct answers are identified by the letters in the right-hand column that are *not* followed by periods.

1. The additive primary colors are . . .
 A. red, green, and cyan
 B. magenta, cyan, and blue
 C. blue, green, and red
 D. green, blue, and yellow
 E. red, blue, and magenta

2. Identify the color sample below that is classified as a secondary additive color.
 A. ▬▬▬▬
 B. ▬▬▬▬
 C. ▬▬▬▬
 D. ▬▬▬▬
 E.

1.

A.

B.

C

D.

E.

3. The letter on the left side of each equation represents the color of light that enters a prism and the letters on the right represent the colors of light that emerge. Identify the correct equation.
 A. $Y = R + G$
 B. $G = R + B$
 C. $R = C + G$
 D. $B = R + M$
 E. $M = G + B$

2.
A.
B.
C.
D.
E

4. Select the combination of colors of light that will produce white light.
 A. $R + G + Y$
 B. $R + B$
 C. $B + Y$
 D. $C + M$
 E. $G + C$

3.
A
B.
C.
D.
E.

5. The major reason why less light emerges from a filter than enters it is because light is lost due to . . .
 A. reflection
 B. diffraction
 C. refraction
 D. transmission
 E. absorption

4.
A.
B.
C
D.
E.

6. When white light enters a yellow filter, the color of the emerging light is . . .
 A. white
 B. yellow
 C. blue
 D. red
 E. None of the above answers is correct.

7. When red light enters a yellow filter, the color of the emerging light is . . .
 A. white
 B. yellow
 C. blue
 D. red
 E. None of the above answers is correct.

8. When yellow light enters a red filter, the color of the emerging light is . . .
 A. white
 B. yellow
 C. blue
 D. red
 E. None of the above answers is correct.

5.
A.
B.
C.
D.
E

6.
A.
B
C.
D.
E.

7.
A.
B.
C.
D
E.

9. Select the name below that does NOT represent a type of photographic filter.
 A. neutral density
 B. contrast
 C. color compensating
 D. polarizing
 E. reciprocity

8.
A.
B.
C.
D
E.

10. The most appropriate use for a CC10M filter would be ...
 A. to control the color balance in color printing.
 B. as a safelight filter for enlarging papers.
 C. to control the appearance of blue sky on color films.
 D. to control the appearance of blue sky on black-and-white photographs.
 E. to protect a camera lens against dirt, fingerprints, and scratches.

9.
A.
B.
C.
D.
E

11. All of the statements except one are valid reasons for using a photographic filter. Identify the exception.
 A. To control glare reflections.
 B. To decrease the intensity of

10.
A
B.
C.
D.
E.

the light falling on the film to permit the use of a slower shutter speed.

C. To increase the intensity of the light falling on the film to permit the use of a faster shutter speed.

D. To prevent any visible light from reaching the film.

E. To prevent invisible ultra-violet radiation from reaching the film.

12. Roman numerals have been substituted for the names of colors on the color triangle. The additive primary colors are represented by the numerals . . .

A. I, II, III
B. I, I, VI
C. I, III, V
D. I, IV, VI
E. V, IV, III

11.
A.
B.
C
D.
E.

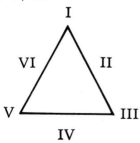

13. The color triangle can be used to determine the effect that a color filter will have on subject colors photographed on panchromatic film. In terms of the modified color triangle above, a filter having the color represented by "I" will lighten (on the print) subjects having colors represented by ...

A. I, II, VI
B. I, III, V
C. I, V, VI
D. II, IV, VI
E. III, IV, V

12.
A.
B.
C
D.
E.

14. Look at the colors below through the filter provided. Select the subject color that would be darkened (on the print) by using this filter over the camera lens with panchromatic film.

A. �
B. ▬▬▬▬
C. ▬▬▬▬
D. ▬▬▬▬
E. ▬▬▬▬

13.
A
B.
C.
D.
E.

15. Assuming that a red filter trans-
mits ⅓ of the light from a gray
subject, the same filter will trans-
mit more than ⅓ of the light
from a ...
 A. green object
 B. blue object
 C. cyan object
 D. yellow object
 E. white object

16. Select the drawing that correctly
represents the effect a magenta
filter has on cyan light.

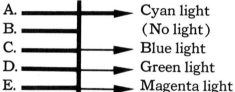

A. ──────────▶ Cyan light
B. ────────── (No light)
C. ──────────▶ Blue light
D. ──────────▶ Green light
E. ──────────▶ Magenta light

14.
A.
B.
C.
D
E.

15.
A.
B.
C.
D
E.

17. The relative amount of entering light that will be transmitted by a filter marked "ND 0.3" is . . .
 A. all
 B. 1/2
 C. 3/10
 D. 1/8
 E. None

18. A CC50Y filter has a density of .50 with . . .
 A. white light
 B. blue light
 C. green light
 D. red light
 E. yellow light

19. Combining a ND .20 filter and a ND .80 filter over a lens will have the same effect as using one . . .
 A. ND .40 filter
 B. ND .60 filter
 C. ND 1.0 filter
 D. ND 1.6 filter
 E. ND 4.0 filter

16.
A.
B.
C
D.
E.

17.
A.
B
C.
D.
E.

18.
A.
B
C.
D.
E.

20. Select the filter that would not
normally be used with ortho-
chromatic film because it trans-
mits none of the light to which
the film is sensitive.
 A. Red filter
 B. Yellow filter
 C. Green filter
 D. Blue filter
 E. ND filter

19.

A.

B.

C

D.

E.

21. Negatives made with and without
a red filter, using the published
filter factor for the negative made
with the filter, should match in
density in . . .
 A. gray subject areas
 B. red subject areas
 C. cyan subject areas
 D. green subject areas
 E. magenta subject areas

20.

A

B.

C.

D.

E.

22. A negative is correctly exposed without a filter at 1/100 second at $f/8$. If a filter having a filter factor of 4 is used and the shutter remains at 1/100 second, the aperture should be changed to . . .

A. $f/2$
B. $f/4$
C. $f/16$
D. $f/32$
E. None of the above answers is correct.

23. A tungsten type color film is rated at an ASA Speed of 120 when the film is used with tungsten illumination and an ASA Speed of 80 when it is used with daylight with the recommended filter. This change of ASA Speed is equivalent to a filter factor of . . .

A. 1
B. 1.5
C. 2
D. 8
E. 12

21.
A
B.
C.
D.
E.

22.
A.
B
C.
D.
E.

94

24. The filter factor of an unidentified filter can be estimated by placing it over the cell of an exposure meter. If the meter indicates the equivalent of one full-stop difference, the estimated filter factor would be . . .

A. 1
B. 2
C. 4
D. 8
E. 10

25. The least likely source of information about filter factors, on the following list, is . . .

A. a filter data book.
B. the data sheet supplied with the film.
C. the filter or the filter package.

23.
A.
B
C.
D.
E.

24.
A.
B
C.
D.
E.

NUMBER WRONG	GRADE
0-2	A
3-5	B
6-9	C
10-12	D
13-25	F

25.
A.
B.
C

REFERENCES

Adams, Ansel, CAMERA AND LENS,
Morgan and Morgan, Dobbs Ferry,
New York, (1st rev. ed.) 1970.
(Information on physical types of
filters, exposure factors, and purposes
for using various filters with black-and-
white films and with color films,
including correction, contrast, haze,
color compensating, light balancing,
and polarizing filters.)

Adams, Ansel, NATURAL-LIGHT
PHOTOGRAPHY, Morgan and
Morgan, Dobbs Ferry, New
York, 1952 (5th printing, 1965).
(Information on the use of a variety
of filters for tone control in black-
and-white photography.)

Adams, Ansel, THE NEGATIVE,
Morgan and Morgan, Dobbs Ferry,
New York, 1968. (Informa-
tion on the effects of using contrast
filters with panchromatic and
orthochromatic films.)

APPLIED COLOR PHOTOGRAPHY
INDOORS, E-76, Eastman Kodak
Company, Rochester, New York.
(Information on polarizing filters and
on filters to be used with color films

to compensate for variations in the color quality of the illumination and for reciprocity effects.)

APPLIED INFRARED PHOTOG-RAPHY, M-28, Eastman Kodak Company, Rochester, New York. (Information on the use of filters with black-and-white and color infrared films.)

COLOR, Life Library of Photography, Time-Life Books, New York, 1970 (Illustrated applications of camera and printing filters to color photography.)

COLOR AS SEEN AND PHOTO-GRAPHED, E-74, Eastman Kodak Company, Rochester, New York. (Explanations of the additive and subtractive systems of reproducing colors, involving filters.)

COLOR PHOTOGRAPHY OUT-DOORS, E-75, Eastman Kodak Company, Rochester, New York. (Information on filters that can be used with daylight and artificial-light color films exposed outdoors.)

COPYING, M-1, Eastman Kodak Company, Rochester, New York. (Information on the use of polarizing filters to eliminate reflections, and color

filters to eliminate defects, control contrast, etc. in copying.)

ENLARGING IN BLACK-AND-WHITE AND COLOR, AG-16, Eastman Kodak Company, Rochester, New York. (Information on filters used to control color balance of color prints.)

Feininger, Andreas, THE COMPLETE PHOTOGRAPHER, Prentice-Hall, Englewood Cliffs, New Jersey, 1965. (Information on color compensating, conversion, contrast, correction, infrared, light balancing, neutral density, polarizing, and ultraviolet filters.)

FILTER DATA FOR KODAK COLOR FILMS, E-23, Eastman Kodak Company, Rochester, New York. (Information on color compensating, light balancing, conversion, and color printing filters, reciprocity, stability, sizes, and handling and care of filters.)

FILTERS FOR BLACK-AND-WHITE AND COLOR PICTURES, AB-1, Eastman Kodak Company, Rochester, New York. (Information on filters as applied to general picture making — how filters work, selecting filters for specific purposes, fitting

filters to the camera, care and handling of filters, etc.)

Hansell, Peter, and Robert Ollerenshaw, editors, LONGMORE'S MEDICAL PHOTOGRAPHY, Chilton, New York, eighth edition, 1969. (Information on contrast, correction, Davis-Gibson, infrared, polarizing, tricolor, and ultraviolet filters, the use of filters in photomicrography, etc.)

Horder, Alan, editor, THE MANUAL OF PHOTOGRAPHY, Amphoto, New York, sixth edition, 1971. (General coverage of a variety of filters for black-and-white photography, and related concepts.)

KODAK AERO-NEG COLOR SYSTEM, M-40, Eastman Kodak Company, Rochester, New York. (Information on the use of color compensating filters and color printing filters in making color diapositive plates, color prints, and color transparencies from aerial color negatives.)

KODAK COLOR DATAGUIDE, Eastman Kodak Company, Rochester, New York, 4th edition, 1969. (Information on light balancing filters, color compensating filters, conversion filters,

and color printing filters. Sample viewing filters and computer dials are included.)

KODAK COLOR FILMS, E-77, Eastman Kodak Company, Rochester, New York. (Information on color compensating, light balancing, conversion, and color printing filters.)

KODAK FILTER SELECTOR, Q-44, Eastman Kodak Company, Rochester, New York. (A dial device containing information on the choice of filters to hold or drop selected colors when photographing copy for photo-mechanical reproduction.)

KODAK FILTERS FOR SCIENTIFIC AND TECHNICAL USES, B-3, Eastman Kodak Company, Rochester, New York. ("Written primarily for laboratory technicians and scientists whose use of filters require extensive spectrophotometric data. The book contains basic information about various types of filters, their physical, optical, and transmission characteristics as well as an indication of their photographic applications.")

KODAK PHOTOGRAPHIC MATERIALS FOR THE GRAPHIC ARTS,

Q-2, Eastman Kodak Company, Rochester, New York. (Information on the use of filters for tone control in black-and-white photomechanical reproduction of colored originals, and for making color-separation negatives. Information also on safelight filters.)

KODAK PHOTOGRAPHIC PAPERS, G-1, Eastman Kodak Company, Rochester, New York. (Information on filters used with variable-contrast photographic papers.)

LIGHT AND FILM, Life Library of Photography, Time-Life Books, New York, 1970. (Illustrated applications of filters to modification of tones, elimination of reflections, etc.)

MAKING DUPLICATES ON COLOR SHEET FILM, E-25, Eastman Kodak Company, Rochester, New York, (Information on filters used to control color balance in making color transparency duplicates with reversal and with negative-positive materials.)

Morgan, Douglas, O., David Vestal and William Broecker, editors, LEICA MANUAL: The Complete Book of 35mm Photography, Morgan and

Morgan, Dobbs Ferry, New York, 1973. (Information on contrast, conversion-light-balancing, correction, color-compensating, ultraviolet, infrared, and viewing filters with applications to picture-making situations.)

Neblette, C. B., FUNDAMENTALS OF PHOTOGRAPHY, Van Nostrand Reinhold, New York, 1970. (Information on physical types of filters, optical and sensitometric effects, etc.)

Neblette, C. B., PHOTOGRAPHY: ITS MATERIALS AND PROCESSES, Van Nostrand, New York, 6th edition, 1962. (Information on absorption curves, the mired system, physical types of filters, optical and sensitometric effects, etc.)

PHOTOGRAPHER'S MATE 3 AND 2, NavPers 10355, Bureau of Naval Personnel, 1966. (For sale by the Superintendent of Documents, U. S. Government Printing Office, Washington D.C.) (Information on the theory, functions, and types of filters, filter factors, filter-film combinations, and applications of filters, including correction, contrast, special purpose, and polarizing filters.)

PHOTOGRAPHY AS A TOOL, Life Library of Photography, Time-Life Books, New York, 1970. (Illustrated applications of filters to false-color photographs and other special effects.)

Pittaro, Ernest, editor, PHOTO-LAB-INDEX, Morgan and Morgan, Dobbs Ferry, New York. (Contains filter factors and other data on a variety of filters.)

PRACTICAL DENSITOMETRY, E-59, Eastman Kodak Company, Rochester, New York. (Information on measuring the red, green, and blue densities of color negatives for the purpose of predicting the required filtration for color printing.)

THE PRINT, Life Library of Photography, Time-Life Books, New York, 1970. (Illustrated applications of variable-contrast filters to black-and-white printing.)

PRINTING COLOR NEGATIVES, E-66, Eastman Kodak Company, Rochester, New York. (Information on the use of white-light printing filters, tricolor printing filters, and viewing filters.)

Ross, Rodger, COLOR FILM FOR

COLOR TELEVISION, Focal Press, London, 1970. (Information on separation, color compensating, neutral density, and viewing filters, and on the use of filters with additive and subtractive printers, scene testers, and telecine projectors.)

Smith, John T., Jr., and Abraham Anson, editors, MANUAL OF COLOR AERIAL PHOTOGRAPHY, American Society of Photogrammetry, Falls Church, Virginia, 1968. (Information on filters for aerial photography with black-and-white film, color film, including anti-vignetting, haze, polarizing, and printing filters.)

SPECIAL PROBLEMS, Life Library of Photography, Time-Life Books, New York, 1971. (Illustrated applications of filters to the solution of photographic problems, including forming stars around light sources, creating the appearance of fog, darkening the sky without altering the foreground, making people disappear, eliminating reflections, and controlling contrast.)

Spencer, D. A., COLOR PHOTOGRAPHY IN PRACTICE, Focal Press, New York, revised edition, 1966,

edited by L. A. Mannheim and Viscount Hanworth. (Information on correction, light-balancing, color compensating, haze, and skylight filters, transmission curves, single-exposure and tricolor printing filters, filter factors, and filter ratios.)

Stroebel, L., VIEW CAMERA TECHNIQUE, Hastings House, New York, and Focal Press, London, 3rd Edition 1974. (Information on the use of contrast, neutral density, polarizing, correction, and conversion filters.)

Todd, H. N., and R. D. Zakia, PHOTOGRAPHIC SENSITOMETRY, Morgan and Morgan, Dobbs Ferry, New York, 1969. (Contains filter curves and other technical information on color compensating, light balancing, and neutral density filters.)

ULTRAVIOLET AND FLUORESCENCE PHOTOGRAPHY, M-27, Eastman Kodak Company, Rochester, New York. (Information on long-wave ultraviolet transmitting filters, interference filters, exciter filters, and barrier filters.)

Yule, John A. C., PRINCIPLES OF COLOR REPRODUCTION, John

Wiley and Sons, New York, 1967. (Information on the use of filters in the photomechanical reproduction of color originals, including the theory and sensitometry of color separation and masking, and filter deficiencies and stability.)

GLOSSARY

absorb: To swallow up light or other radiant energy, converting it to heat.

acetate filter: A sheet of colored cellulose acetate used to modify the quality of radiation—especially in safelights and projection printers. Acetate filters tend to be relatively inexpensive, but are usually less uniform in thickness and transmittance than other types.

additive: Identifying a color reproduction process that is capable of producing a wide range of colors by combining controlled amounts of primary colors of light—normally red, green, and blue. Compare with subtractive.

anti-vignetting filter: A neutral density filter that is darker in the center than at the edges, used, for example, to reduce falloff in illumination from the center to the edges of the film with some wide-angle lenses.

aperture: An opening in a plate which otherwise obstructs light and other radiant energy; specifically, the diameter of the opening.

ASA: Identifying a film speed deter-

mined by a method specified in the American National Standards Institute (ANSI) published standards. The method varies for different types of films such as black-and-white negative, color negative, and color reversal materials.

attenuate: To reduce energy. A filter, for example, reduces radiant energy by converting absorbed radiation to heat.

bandwidth: The range of wavelengths between those at which the transmittance of a filter is half the maximum transmittance or the density of a filter is 0.3 above the minimum density.

barrier filter: When photographing fluorescence, a filter used in front of the camera lens to absorb the radiation that produces the fluorescence (ultraviolet radiation, for example), while transmitting the radiant energy produced by the fluorescence. The barrier filter prevents the fluorescence from being obscured by exciting radiation to which the film is sensitive. Also see exciter filter.

base: A sheet-like material that is used to support one or more photo-

sensitive layers, as in photographic film and printing paper.

black: Identifying an object of low reflectance (or transmittance) and neutral color, or a perception of low lightness and indistinguishable hue.

blackbody: A hypothetical material (approximated by carbon) that produces a maximum flow of radiant energy when heated to incandescence. The color temperature of illumination (for example, 3200 K) is the actual temperature of a blackbody heated to produce a visual match.

blue-sensitive: A photographic material that is sensitive to ultraviolet radiation and short-wavelength visible radiation (blue light) only, as distinct from orthochromatic and panchromatic.

Brewster's Angle: The number of degrees between an incident ray of light and the perpendicular for which polarization of the reflected ray from a nonmetallic, glossy surface is at a maximum.—specifically, the angle for which the tangent equals the refractive index.

brightness: The aspect of visual perception that is approximately corre-

lated with the luminance of objects seen as light sources. Since brightness is a psychological concept, there are no units of measurement.

chroma: The color attribute which varies with saturation of a hue—for example, the extent to which a blue pigment differs from a gray pigment of equal lightness.

color: (1) As applied to light sources, the relative energy produced at different wavelengths. (2) As applied to objects, their reflection or transmission properties for different wavelengths of light. For example, yellow objects reflect little blue light and much green and red light. Yellow filters transmit little blue light and much green and red light. (3) That aspect of visual perception associated with the attributes of light identified as hue, saturation, and brightness, or associated with the attributes of objects identified as hue, chroma, and lightness.

color balance: A general term for the perceived accuracy of reproduction of subject colors (especially neutral colors) in a photograph. If the image of a gray scale appears too red, for

example, the color balance is said to be red.

color compensating (CC) filters: Identifying a class of filters produced in red, green, blue, cyan, magenta, and yellow hues and a variety of densities from .025 to .50, used to produce controlled changes in the color balance of color photographs.

color separation: The operation of making records of the red, green, and blue light from a subject, a necessary step in some color reproduction processes. The filters used for this purpose are sometimes identified as color separation filters.

color temperature: A scale for rating the color quality of illumination. The color temperature of illumination (for example, 3200 K) is the actual temperature of a blackbody heated to produce a visual match.

color temperature meter: A photoelectric instrument that provides an estimation of the color temperature of a source in kelvins (3200 K, for example) by comparing the relative illuminances in two or three spectral regions, typically red and blue.

complementary colors: Identifying light from two sources which can be mixed to appear white, or two dyes, pigments, or other colorants which can be mixed to appear neutral in color.

contrast: Relative lightness variations in a scene or image.

contrast filter: A strongly colored transparent material that effectively absorbs red, green, blue, cyan, magenta, or yellow light.—commonly used in black-and-white photography to lighten or darken selected subject colors.

conversion filter: A filter designed to alter the color temperature of light to correspond to that recommended for a color film. Orange conversion filters, for example, are used for exposing tungsten type color films by daylight.

correction filter: A type of camera filter used to obtain more realistic tonal representations of subject colors on black-and-white photographs. Correction filters are normally yellow for daylight illumination and green for tungsten illumination.

cross-screen filter: A clear glass

"filter" containing engraved lines, used for night photographs to obtain star patterns around bright lights.

daylight: The combined illumination from the sun and sky. Although the color temperature of average daylight is considered to be approximately 5500 K, the color temperature varies over a wide range with changes in the time of day, atmospheric conditions, etc.

density: A measure of the light-absorbing characteristics of an area on a photograph or other material. Specifically, density is the logarithm to the base 10 of the opacity, or the minus logarithm of the transmittance.

depth of field: The range of object distances within which objects are imaged with acceptable sharpness. Depth of field varies with numerous factors including f-number, focal length, object distance, viewing distance, and viewer criterion.

dispersion: The separation of light into its component colors, resulting in a spectrum.

emulsion: (1) Identifying the layer on photographic film or paper that is

sensitive to light or other radiant energy. (2) A dispersion of silver halide crystals in gelatin or other suitable material. Preferred term—photographic emulsion.

exciter filter: When photographing fluorescence, a filter used in front of the source of radiation to absorb most of the radiation except that which produces the fluorescence. Also see barrier filter.

exposure: The quantity of light per unit area received by a photosensitive material, commonly expressed as exposure equals illuminance times time ($H = I \times T$ formerly $E = I \times t$). Preferred term—photographic exposure.

exposure-control filter: A neutral density filter—a filter that absorbs approximately equal proportions of all wavelengths of light.

exposure meter: A light-measuring instrument used to determine appropriate time and aperture settings on a camera for a desired exposure effect. Incident-light (illuminance) meters measure the light falling on the subject, and reflected-light (luminance) meters measure the light reflected from, trans-

mitted by, or emitted by the subject.

film speed:　A number intended to be used with an exposure meter to determine the camera settings that will produce an image of satisfactory quality, for example, ASA 125.

filter:　A layer of more or less transparent material used in optical systems to modify the quality or quantity of radiation. Three basic types of modifications are selective absorption by wavelength (color filters), nonselective absorption by wavelength (neutral density filters), and selective absorption by angle of polarization (polarizing filters).

filter factor:　A multiplying number —applied to the exposure time, for example—used to compensate for absorption by a filter. The intent is to represent neutral subject tones with the same density in images made with and without a filter.

filter stability:　The relative ability of a filter to resist the fading influence of light. Since no dyes are permanent, a stable filter is one that fades slowly.

fluorescent lamp:　A light source in

which light and ultraviolet radiation are produced by electricity flowing through mercury vapor. The spectral energy distribution is a combination of a continuous spectrum from the fluorescence and a discontinuous spectrum from the mercury radiation.

f-number: A number ($f/16$, for example) obtained by dividing the focal length of a lens by the effective aperture, used to control the amount of light transmitted by a lens. Selected *f*-numbers, usually representing the maximum aperture and consecutive full stops, are normally printed on the lens mount. Also known as "relative aperture" or "aperture setting."

full stop: A change in an aperture that corresponds to multiplying or dividing the lens transmittance by 2 or the *f*-number by the square root of 2. Consecutive *f*-numbers in the conventional series represent full stops; for example, $f/8, f/11, f/16, f/22$.

gelatin filter: A thin (0.1mm, for example) sheet of dyed gelatin used in optical systems to modify the quality or quantity of radiation. Some gelatin

filters are mounted between glass plates for added protection. Compare with glass, acetate, and liquid filters.

glare: Identifying a mirror-like reflection, as distinct from a diffuse reflection.

glass filter: A sheet of colored glass or a thin sheet of dyed gelatin mounted between glass plates, used to modify the quality or quantity of radiation. Compare with gelatin, acetate, and liquid filters.

graduated filter: A layer of more or less transparent material that has a systematic change in absorption characteristics across its surface. The upper portion of a graduated camera filter, for example, may be yellow to darken blue sky on photographs while the lower portion is clear so that the reproduction of foreground objects will not be affected.

gray scale: A series of neutral tones arranged in sequence from light to dark, usually in discrete, calibrated steps. A gray scale is often included with a subject or added at an intermediate stage of a reproduction process as a standard for control purposes.

haze filter: Any of various filters that are used to reduce the effects of scattering of radiation by suspended particles in the atmosphere. Since short wavelength radiation is scattered more than long, haze filters typically absorb ultraviolet radiation and some blue light.

hue: The attribute of color that varies with the wavelength composition of the light and is associated with names such as red, green, and blue.

incident: Identifying light or other radiant energy falling on a surface, as distinct from reflected, transmitted, and emitted light. An incident light (illuminance) meter measures the light falling on a surface.

infrared: Electromagnetic radiation similar to light, but of longer wavelength and invisible. Only photographic materials that have been specially sensitized during manufacture are capable of recording infrared radiation.

interference filter: An optical device consisting of two reflecting surfaces separated by a transparent film of a thickness that produces constructive interference of, and therefore transmits, only a narrow range of wavelengths.

Kelvin: Identifying a temperature scale used for rating the color quality of illumination—for example, 3200 K. The intervals on the Kelvin scale are equal to those on the Celsius scale, but 0 K corresponds to −273 C.

light: Electromagentic energy that can serve as a stimulus for the human visual process, with a range of wavelengths from approximately 400 to 700 nanometers.

light-balancing: Identifying a class of filters designed to produce relatively small changes in color temperature (in comparison with conversion filters). Bluish light-balancing filters have a cooling effect on the color balance of color photographs—yellowish filters have a warming effect.

liquid filter: Colored water or other liquid in a transparent container having parallel sides, used especially in front of light sources to alter the quality of radiation.

minus −: Identifying the color of maximum absorption by a filter. A magenta filter, for example, has maximum absorption of green light so may be identified as a minus-green filter.

mired: (Contraction of MIcro REciprocal Degree.) Identifying a scale for rating the color quality of illumination. Specifically, the mired value of illumination is equal to one million times the reciprocal of the color temperature, or mired

$$\text{value} = \frac{1{,}000{,}000}{\text{color temperature in kelvins}}$$

mired shift: A change in the color quality of light, as measured in mireds. Since a given filter produces approximately the same mired shift regardless of the mired value (or color temperature) of the illumination, light balancing and conversion filters can be calibrated in terms of the mired shift value—for example, 131, −112.

monochromatic filter: A filter (or combination of filters) that transmits a narrow range of wavelengths of light or other radiant energy—ideally, a single wavelength.

nanometer (nm): A unit of length which is one billionth of a meter, the preferred unit of wavelength for light. Nanometer is equivalent to and replaces millimicron.

narrow-band filter: A filter (or

combination of filters) that transmits a narrow range of wavelengths of light or other radiant energy.

negative: A photographic image in which light subject tones are reproduced as dark and dark tones as light.

neutral density: Identifying a filter that absorbs approximately the same proportion of all wavelengths of light. Neutral density filters are used to reduce the amount of light without altering the quality.

non-color sensitized: A photographic material that is sensitive to ultraviolet radiation and short-wavelength visible radiation (blue light) only, as distinct from orthochromatic and panchromatic.

optical filter: A layer of more or less transparent material used in optical systems to modify the quality or quantity of radiation, as distinct from an air filter, electronic filter, etc.

orthochromatic: A photographic material that is sensitive to green light in addition to blue light and ultraviolet radiation, as distinct from panchromatic and blue-sensitive.

panchromatic: A photographic mate-

rial that is sensitive to red light in addition to green and blue light and ultraviolet radiation, as distince from orthochromatic and blue-sensitive.

photographic emulsion: A dispersion of silver halide crystals in gelatin or other suitable material.

photographic exposure: The quantity of light per unit area received by a photosensitive material, commonly expressed as exposure equals illuminance times time ($H = E \times t$, formerly $E = I \times t$).

polarized light: Light which vibrates essentially in one plane, as distinct from ordinary light which vibrates randomly in many directions. Polarized light is produced by reflection from nonmetallic surfaces at a specified angle (Brewster's Angle), by scattering from small particles (light from blue sky, for example), or by transmission, through any of various polarizing materials (a polarizing filter, for example).

positive: A photographic image in which the tones are in approximately the same relationship as in the original, that is, light tones are reproduced as light and dark tones as dark.

primary colors: In the additive system of color reproduction, red, green, and blue light, which can be combined in varying proportions to duplicate any hue. In the subtractive system, cyan, magenta, and yellow dyes or other colorants, which can be combined in varying proportions to duplicate any hue.

print: A photographic image made from a negative or positive image, rather than directly from an original scene, usually for the purpose of being viewed or of being reproduced (photomechanically, for example) for mass viewing. Typically a positive image on a paper base for still photography and a positive image on a transparent base for motion picture photography.

prism: A transparent optical element, having only flat surfaces, used to refract, reflect, or disperse radiation. A triangular prism, for example, can be used to separate an incident beam of light into its component colors.

proportion: A relationship between things or magnitudes. In numerical form, a one to two proportion is variously written as $1:2$, $1/2$, 0.5, and 50 percent.

reflected light: The part of incident light that is returned by a surface—that is, the part that is not absorbed or transmitted.

reversal material: Photographic film or paper on which positive images are produced directly from positive originals, as distinct from negative materials and positive materials. The following sequence of steps is typical of the processing for reversal materials: image exposure, development, bleaching, fogging exposure or chemical fogging, second development, fixation, washing, and drying.

safelight filter: A filter used over a light source in a darkroom, having absorption-transmission characteristics designed to enable the photographer to see without allowing objectionable fog to be formed on the photographic materials being handled. Yellow safelight filters, for example, absorb most of the blue light to which printing papers are sensitive.

secondary colors: In the additive system of color reproduction, colors formed by combining two primary colors—cyan (blue plus green),

magenta (red plus blue), and yellow (red plus green).

sharp-cutting: Identifying filters that have an abrupt transition between wavelength regions of high and low transmittance.

shutter speed: Exposure time, usually in reference to exposing film in a camera. For general purpose photography, the effective exposure times are assumed to be the same as the corresponding shutter speeds marked on a camera or lens mount. For critical work, compensations are sometimes made for discrepancies between the two values.

sky filter: A smoothly graded filter used to make sky tones more dramatic. The upper colored part of the filter is typically yellow or red for black-and-white photography, and blue for color photography.

skylight filter: An almost colorless pink filter that absorbs a large proportion of ultraviolet radiation and a small proportion of blue and green light, used on a camera when making color photographs of subjects in open shade that are illuminated by blue skylight, to

produce a more neutral color balance.

spectral: Related to a spectrum. Spectral sensitivity, for example, is a measure of the response of a photographic film or other material to a narrow range of wavelengths of electromagnetic energy.

spectrogram: A photographic record of the spectrum of light and other electromagnetic radiation used to provide information concerning the spectral quality of the light or the spectral response of the photographic material.

spectrophotometric curve: A graph on which transmittance and density of a filter, for example, are represented on the vertical axis and wavelengths are represented on the horizontal axis.

specular: Identifying a mirror-like reflection, as distinct from a diffuse reflection. Syn. — glare.

split filter: A filter on which half of the area is clear and the other half is colored, used especially to darken the sky without altering the foreground.

subtractive: Identifying a color reproduction process that is capable of producing a wide range of colors by

combining controlled amounts of dyes, pigments, or other colorants—normally cyan, magenta, and yellow. Red, for example, is formed by superimposing magenta dye (which removes green from white light) and yellow dye (which removes blue from white light). Compare with additive.

transmit: To permit light or other energy to pass through, as distinct from absorb and reflect.

transmittance: The ratio of transmitted light to incident light. For example, if 10 units of light fall on an area and one unit is transmitted, the transmittance is 1/10 (or .10, or 10%).

transparency: An image intended to be viewed by light that passes through the image and base, as distinct from a print on a paper base which is viewed by reflected light.

tungsten: Identifying a light source that contains a filament made of tungsten metal which is heated to incandescence during use. The spectral energy distribution of the light produced varies with the temperature of the filament.

ultraviolet: Electromagnetic radiation similar to light, but of shorter wavelength and invisible. Most photographic materials are sensitive to ultraviolet radiation.

value: An attribute of color in the Munsell system of color notation, corresponding to lightness. White, for example, has a high value.

white light: Light that is perceived by the viewer to be neutral in color. Although daylight and tungsten light differ considerably in color balance, both contain energy throughout the visible spectrum and both are generally perceived as being white.

(A number of the above definitions are from the DICTIONARY OF CONTEMPORARY PHOTOGRAPHY by L. Stroebel and H. N. Todd, Morgan and Morgan, Dobbs Ferry, New York, 1974.)

INDEX

The numbers refer to the program frame numbers. The Glossary begins on page 109.

The increased exposure time resulting from the use of a neutral density filter on the camera lens permitted the lens to be zoomed while the shutter was open. This abstract effect was used to illustrate the concept of population explosion.

Photo by: Robert S. Harris

The color photographs on pages 140-143 were made from color transparencies by means of the tone-separation process and color filters. A series of high-contrast negatives was made from each continuous-tone transparency with changes in exposure to record different tonal areas. An exposure was then made on color printing paper from each high-contrast negative in turn, registering the images and using a different filter for each exposure. The bird photograph on page 141 had an additional exposure using the tone line technique. Other false-color effects can be obtained from continuous-tone black-and-white negatives.

Photo by: Robert S. Harris

Large gelatin color filters (gels) were used over the light sources that produced the reflections on the lamp. The three additive primary colors (red, green, and blue) and the three subtractive primary colors (cyan, magenta, and yellow) are represented to illustrate the concept of primary light.

Photo by: Robert S. Harris

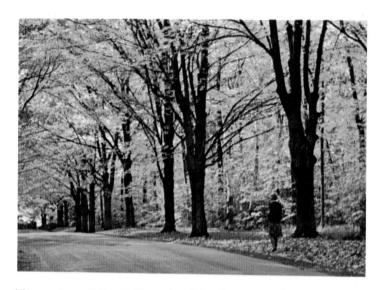

The color of the foliage in this photograph was
enhanced by using a CC10Y filter plus a CC10R
filter on the camera lens.

Photo by: W. George Thornton

A red filter was used on the camera lens to increase the dramatic effect of this photograph of a solar eclipse made on daylight type color film.

Photos by: John Daughtry

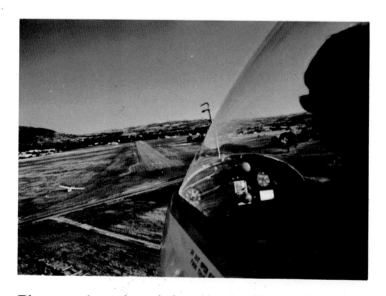

Photograph made on infrared color film, with a
yellow filter on the camera lens, for a false-color
effect.

Photograph made with separate
exposures through red, green, and blue
filters. A short delay between exposures
produced color fringing effect due to
movement of the flame.

Photo by: Robert S. Harris

Pressure was applied to the human skull which had been coated with a plastic. Two polarizing filters, one over the light source and one on the camera lens, produced color variations that reveal stress patterns.

Photo by: Robert Golding

A polarizing filter on the camera lens, rotated to the proper angle, reduced reflections on the water. The comparison photograph on the opposite page was made without a polarizing filter.

Photos by: W. George Thornton

A false-color photograph produced on infrared color film with a blue-absorbing filter on the camera lens. The comparison photograph on the opposite page was made on conventional daylight type color film.

Photos by: W. George Thornton

154

A polarizing filter on the camera lens, rotated to the proper angle, darkened the blue sky and reduced reflections. The comparison photograph on the opposite page was made without a polarizing filter.

Photos by: W. George Thornton

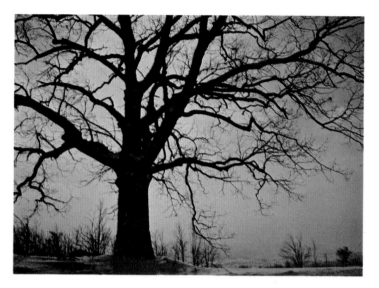

A filter can be placed over a normal transparency to alter the color balance for viewing or reproduction. A CC40M filter was used for the above effect. The unfiltered photograph is on the opposite page.

Photos by: W. George Thornton

A color compensating filter held
between the camera and the girl
shows a change in color balance in the
area behind the filter. Placing the filter
on the camera lens would change the
color balance of the entire photograph.

Photo by: Robert S. Harris